the walls have the floor

The MIT Press
Cambridge, Massachusetts
London, England

the walls have the floor

Mural Journal, May '68

edited by Julien Besançon

foreword by Tom McDonough
afterword by Whitney Phillips
translated by Henry Vale

Originally published by Éditions Tchou in 1968 as *Les murs ont la parole: journal mural, mai 68.*
© 2007 Tchou, 6 rue du Mail, 75002 Paris, France.

This book was set in Palatino and Neue Haas Grotesque by The MIT Press. Printed and bound in the United States of America.

Library of Congress Cataloging-in-Publication Data

Names: Besançon, Julien, 1932– author.
Title: The walls have the floor : mural journal, May '68 / edited by Julien Besançon ; foreword by Tom McDonough ; afterword by Whitney Phillips and Ryan M. Milner.
Other titles: Murs ont la parole English
Description: Cambridge, MA : The MIT Press, MA, 2018. | Includes bibliographical references.
Identifiers: LCCN 2017041848 | ISBN 9780262038027 (hardcover : alk. paper)
Subjects: LCSH: Riots—France—History—20th century | General Strike, France, 1968. | Student movements—France—Paris—History—20th century. | Graffiti—France—Pictorial works.
Classification: LCC DC412 .B413 2018 | DDC 944/.3610836—dc23 LC record available at https://lccn.loc.gov/2017041848

10 9 8 7 6 5 4 3 2 1

contents

foreword

Tom McDonough

On June 20, 1968, a curious little volume first appeared on the shelves of Parisian bookshops: *Les murs ont la parole* collected the graffiti that had blossomed on the walls of the city the previous month, as initially students and then workers refused their socially approved roles in university and factory, ceasing production of knowledge or commodities, in order to engage in a month-long, generalized debate over what sort of world they wished to live in. *The Walls Have the Floor* was, as the French say, published *à chaud*, hot on the heels of these tumultuous events. In this third week of June, the barricades along the streets of Paris's Left Bank had barely been dismantled, some workers were still on strike, and the elections that would resoundingly confirm Charles de Gaulle's continued hold on presidential power were a few days away. University rectors and factory managers would have only just begun painting over the slogans,

watchwords, and sayings that compose the contents of this book, whose format *à l'italienne*—its landscape orientation—makes it look something like a brick, a red-and-black flag, or perhaps, if held vertically, the kind of notebook journalists might carry around to jot down impressions of the events unfolding around them.

That's certainly appropriate, since the collector of the phrases gathered in *The Walls Have the Floor* was Julien Besançon (1932–2017), a reporter and editor in chief at the radio station Europe no. 1. Although only in his mid-thirties at the time of the strikes, he already had well over a decade and a half of professional experience, having begun as a print reporter in the early 1950s before switching over to radio in 1955, starting at Europe no. 1 the year of its founding. His was a familiar voice during the Algerian conflict, broadcasting major events from the May 1958 crisis that brought de Gaulle back to power through the 1962 Évian Accords that ended the war and recognized Algerian independence. Later in the decade, he reported from the front during the 1967 Six-Day War between Israel and the Arab states, an experience that he recounted in a successful

book. Europe no. 1 was known for these kinds of eyewitness accounts, as opposed to the more scripted narratives of "official" state French radio; indeed, during May '68, it became a significant source of information as government stations refused to speak of the protests erupting in the streets. Reporters for Europe no. 1, including Besançon, relayed the demonstrations as they happened, describing the melees between students and French riot police from apartment balconies overlooking the streets of the Left Bank. Not a participant in, then, but a keen observer of the events. It was amid this intense atmosphere of street fighting and ideological debate that Besançon assembled the materials he would preserve in *The Walls Have the Floor*.

His book was published by Éditions Tchou—better known at the time for its *Guides noirs*, esoteric guidebooks to various French cities and regions for tourists wishing to escape the tedium of their *Guides bleus*. *The Walls Have the Floor* could itself be considered a kind of guide to the revolutionary city, a tour of its rapidly disappearing sites of contestation as mapped by the fleeting inscriptions on its walls. It was—along with

Mai 68 affiches, a collection of revolutionary posters introduced by Jean Cassou, critic and former director of Paris's Musée National d'Art Moderne, also released in June 1968 by Tchou—part of a wave of largely opportunistic publishing in the wake of May, attempts to simultaneously preserve ephemeral documents and capture a market among the primarily youthful participants and would-be participants in the events. And Besançon's book certainly did capture a market, reportedly selling 100,000 copies within three weeks of its first publication. Those twin impulses of nostalgia and marketing continue to drive the cottage industry that has sprung up in France around the memory of May '68 for half a century now, and every milestone anniversary of the events has only seen an increase in the number of such publications, with their appeal to an aging population of veterans of that year's struggles. If Cassou's volume of posters is now a collector's item long out of print, Besançon's anthology was rereleased in 2007, in anticipation of May's fortieth anniversary; it appeared unchanged but for a somewhat sardonic afterword by the author, in which he noted how time has altered the idealism of the 1960s,

so that Daniel Cohn-Bendit, former leftist student leader, and Charles Pasqua, who helped rally support to de Gaulle during the May crisis, could now sit side by side as colleagues in the European Parliament.

And yet his small book continues to radiate an energy that transcends such cynicism. The English translation you hold in your hands returns us to a moment when the walls of Paris became pages on which a generation in revolt recorded its anger, its desire, and its poetry. Besançon's compilation is unique in its focus on these graffiti rather than the better-known posters produced within various ateliers during May and June, and even into the summer and fall of '68. Those familiar with these posters may notice some overlap with the slogans spray-painted onto the city's walls: in both we find, for example, the famous "We are all German Jews" or the lesser-known but still eloquent "The State is each one of us." The graffiti, however, represent a significantly more spontaneous, bottom-up expression than most of the posters. The designs of the latter were subject to committee approval in people's studios, and their rather anodyne demands for improvements in factory working conditions or

institutional reforms of the police, the state-run radio, and the like point to the consensus-based decision-making processes and the influence of the established leftist *groupuscules* whose reach extended into the ateliers. The graffiti, by contrast—often strongly Situationist in tone—could be philosophical, poetic, or crude, the mark of a moment's inspiration or of long reflection. They are perhaps the finest realization of that subversive "seizure of speech" Michel de Certeau spoke of as the distinguishing trait of May '68.

Besançon identifies each phrase by its location, the vast majority of which are tied to the sprawling network of the French state's system of higher education: various universities scattered around Paris's Left Bank, from the Sorbonne to Censier and the professional Schools of Medicine, Pharmacy, and so on; the narrow streets surrounding them; and the notorious suburban campus in Nanterre, just to the west of the city. If many of these sites are likely unfamiliar to an English-speaking audience, in 1968 they would have evoked not only particular locales but also specific ideological tendencies within the occupation movement: the

Sorbonne's hallowed Grand Amphithéâtre, seat of the student general assembly, where disputes raged over the future of the movement; Nanterre, home to the vocal and violent *enragés*, who took their inspiration from the Situationist International; or the Odéon Theater, which prominent members of the Parisian counterculture, Jean-Jacques Lebel at their head, transformed into a permanent happening. The specificity of the graffiti's locations might be contrasted with the anonymity of their authors—for obvious reasons, most protesters spray-painting the walls during May preferred to remain nameless. But, of course, these traces were left behind by *someone*, and with the passage of time we are able to identify at least a few of those responsible. Christian Sébastiani, for example, was a young Situationist whose looping schoolboy handwriting is discernible in many of the most expressive of the spray-painted slogans—"Liberty is the crime that contains all crimes / it's our ultimate weapon" or "Culture is the inversion of life." Guy Debord dubbed him "the poet of the walls" in honor of his imaginative contributions to the revolt. Another of the best-known phrases of May '68, "Under the

paving stones, the beach," was the joint invention of medical student Bernard Cousin and Bernard Fritsch, a.k.a. Killian, both working at an advertising agency at the time; inspired by the Situationists, they devised the slogan one night over beers at the venerable rundown café la Chope, on the place de la Contrescarpe, an old haunt of Debord and his friends.

Such a search for individual authors, however, contravenes the fundamental significance of these graffiti: the sense that knowledge is not the possession of a few, of "mandarin" professors or government technocrats, but is something held in common by all. We hear the echoes of such a "commons" of knowledge, and of a long radical tradition, in the citations that crop up repeatedly in the inscriptions. The French revolutionary Louis de Saint-Just was particularly popular, with variations on his "Happiness is a new idea in Europe" appearing, along with "No liberty for the enemies of liberty" and other slogans of the Jacobin Terror. Surrealist poet André Breton comes into view with a pertinent quote from an essay of 1930: "Imagination is not a gift but above all an object of conquest." Further afield, American author Ambrose Bierce is cited from his corrosive

Devil's Dictionary—translated into French in 1955 and given a foreword by Jean Cocteau—with a definition of "Amnesty": "act by which sovereigns usually pardon the injustices they've committed." Even Saint Augustine, Christian bishop and theologian, is conscripted into the revolution, with a paraphrase from his remarkable sermon celebrating the commons: "It is because property exists that there are wars, riots, and injustices." Of course, we should note the sociological specificity of such a practice of citation: only those who enjoy the privilege of an education in philosophy and literature could plunder their history so freely. Notably absent from Besançon's collection are any graffiti from the countless factories on strike in May. From the photographic evidence, they tended more toward the informative than the poetic: variations on "general strike," "occupied factory," and expressions of worker solidarity dominated, generally on the gates or street frontages of such places of work. But one regrets that Communist-controlled trade unions largely prevented reporters like Besançon from exploring beyond the factory entrance, depriving us of the potentially rich store of subversive language within.

The Walls Have the Floor is, then, an immediate transcription of the discourse that student revolutionaries were inventing in the heat of their struggle. But it also takes its place within a longer French fascination with graffiti as a popular art form, one that—like so-called primitive art or *art brut*—was seen as a subversion of Western canons of taste and beauty. This was especially pronounced within the wide circle of surrealism in the 1930s, as found in Brassaï's 1933 photo essay on Parisian graffiti, "From the Cave Wall to the Factory Wall," or anthropologist Marcel Griaule's publication in the same year of Abyssinian graffiti from Ethiopia. But in some of the most personal, evocative phrases recorded by Besançon—"Already 10 days of happiness," found at the Censier campus, or the utter simplicity of the biblical name "Eve," written on a wall at Nanterre—we catch a glimpse of an even deeper history, stretching back to Nicolas-Edme Restif's late-eighteenth-century *Mes inscripcions* (*sic*), an accounting of the autobiographical phrases he had carved into the quays along the Seine. Thus, the spray-painted expressions of May '68 rejoin the long saga of graffiti as a public practice of writing, or more specifically of what we

might call a "writing-against"—with a sense that we are here dealing with popular inscriptions that counter those formal, official ones found on the walls of the city. In the eighteenth century, the latter were governmental; by May '68, as in our own moment, they were more likely to be commercial. In either case, these many hands trace an accounting of their hopes, desires, and dreams across the obdurate surface of everyday life. Even when we have lost the echo of particular references, or the urgencies of the era, their eloquence remains.

translator's introduction

Henry Vale

FALSTAFF
> An old lord of the council rated me the other day in the street about you sir, but I marked him not; and yet he talked very wisely, but I regarded him not; and yet he talked wisely, and in the street too.

PRINCE
> Thou didst well; for wisdom cries out in the streets, and no man regards it.

—Shakespeare, *Henry IV, Part 1*

This translation of the graffiti of May 1968 (as edited by Julien Besançon) is offered as a supplement to the accounts of the uprising already available in English.[1] There is no shortage of literature recounting and analyzing the events of that month in France, and this collection makes no claim to

such elucidation: it is purely documentary. The voices it offers are grounded in just one of the directives celebrated in that period: Let no one speak in your place.

The collection does stand on its own, however, and may rightly take its place alongside such other famed graffiti collections as those of the Tower of London, the ruins of Pompeii, and the pseudonymous Hurlo Thrumbo's eighteenth-century miscellany, *The Merry-Thought.*

A remark found in the pages of *The Blue Flowers* by Raymond Queneau might well be offered here (especially given that Queneau himself makes a brief appearance on the walls in question): "You're just making a lot of fuss about nothing," a character tells the disgruntled fence-painter, Cidrolin. "Graffiti, what are graffiti? Simply literature." While graffiti has come to find acceptance as an art form over the past few decades (provided it remains within a controlled space), this "simply" may still come across as an understatement. Graffiti as literature is of interest for several reasons: it is often anonymous (if one leaves aside the self-identifying tags) and thus frequently functions as a collaborative collage; it offers

something of a prehistory to today's social media channels and online shit storms; and, like pornography (its not infrequent companion in anonymity), it is a form of writing grounded in an *urge.* The slogans of '68 stand as a testament to enthusiasm, engagement, and a new experience of the everyday—offline, in the streets.

Brackets indicate alterations made by a second party to earlier graffiti; *script font* indicates graffiti originally in English. Acronyms have been left as they are: see the glossary for explanations, context, and any other such pertinent background information.

Many of the graffiti texts borrow from or play off of authors both attributed and unattributed, including Saint Augustine, Mikhail Bakunin, Charles Baudelaire, Ambrose Bierce, Napoleon Bonaparte, André Breton, René Char, Georges Clémenceau, René Daumal, Jean Genet, André Gide, Che Guevara, Heraclitus, Friedrich Hölderlin, Alfred Jarry, Jean de La Fontaine, Claude Lévi-Strauss, Karl Marx, Charles Maurras, Henri

Translator's Introduction

de Montherlant, Friedrich Nietzsche, Charles Péguy, Benjamin Péret, Plutarch, Jacques Prévert, Raymond Queneau, Pierre Reverdy, the Duc de la Rochefoucauld, Louis Antoine de Saint-Just, George Santayana, Baruch Spinoza, Henri Tolain, Mao Tse-tung, Tristan Tzara, Miguel de Unamuno, Paul Valéry, Jules Vallès, Raoul Vaneigem, Paul Verlaine, and Émile Zola. It would be unseemly to bog down the book with excessive academic graffiti, so biographies and notes have been kept to a minimum, the impulse to "explain" has been curbed, and the glossary has been restricted to information directly tied to the events of May '68 that may not be immediately clear to today's English reader.

In the spirit of the graffiti, puns (both good and bad) have been rendered into English when possible; otherwise, such wordplay is merely noted.

Note

1. These include, among many others: *Enragés and Situationists in the Occupation Movement, France, May '68* by René Viénet; *Obsolete Communism: the Left-Wing Alternative* by the Cohn-Bendit brothers; "Paris May 1968" by Solidarity, in *Beneath the Paving Stones*, ed. Dark Star; "What Happened" by Angelo Quattrocchi, in Quattrocchi and Nairn, *The Beginning of the End*; and *Paris '68* by Marc Rohan. Particularly recommended for its scope, contextualization, and balanced viewpoint is *May '68 and Its Afterlives* by Kristin Ross. See the bibliography for further reading.

the walls have the floor

Once again it was the time of the cherries.

The Paris Commune was about to turn a century old. Building facades were still being washed. Walls were white, an ageless uniform white; the Sorbonne alone, or almost, remained black. At that point, the street meant nothing more than traffic jams. "Post no bills" was not yet a poem but a law from another century.

One of the first such poems, a spray-painted bit of red dynamite, exploded: "Prohibiting prohibited." It was an attack on the whitewashed fortress that, by coloring the wall, aimed to tear down all walls.

"Dust removal underway" swept a sign, and the mural journal, minus the ideograms of Peking, but wielding instead the ideas of Proudhon and Bakunin, surrealists and Situationists, shook France down to its oldest barricades, crushed like the cherries of May under the frescoes of Puvis de Chavannes, the amphitheater hallways, the towers of the Faculty of the Sciences, and the Louis XV and Île Saint-Louis mansions.

Graffiti itself became a form of freedom. And how often did people write, in all sincerity: "I have nothing to write." They were not naïve: they cried out to feel they belonged.

It was a celebration of anonymity. Those who quoted others did not sign their texts, annexing authorship to the circumstances.

But these cries – written with nail on chalk, limestone on bond-stone, and ink on paper, denying politics, contesting philosophy, aesthetics, poetry – these were creative acts. A vertical forum, democracy via cross-outs: add-ons and replies established a dialogue.

The whitewashing of June is already flattening out the black and red pamphlets of May: they're repainting.

For the first time, a historical monument had no pretentions of being one.

The discord and the discussions, an ephemeral monument of a particular spring, will have disappeared.

Should these large-eared walls, which had laid claim to speech, no longer have eyes? Why so?

Hence this collection.

Julien Besançon

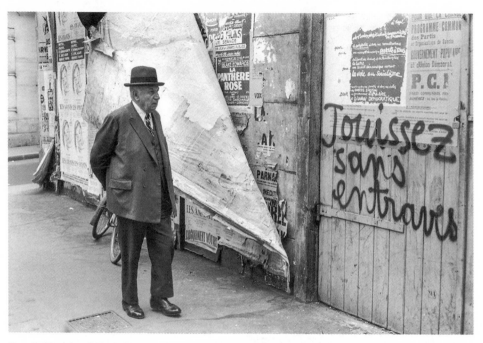

Rue de Vaugirard, Paris, France, 1968. Henri Cartier-Bresson/Magnum Photos.

Here, one spontanates. *Censier*

Wall bathing infinitely in its own glory. *Hall A. Nanterre*

To be a student is easy; to remain one is to go on strike. *Pharmacy*

Contestation. But *con* before anything.[1] *Stairway C. Nanterre*

The dream is reality. *Censier*

God, I suspect you're a left-wing intellectual. *Condorcet*

Thinking together no. Pushing together yes. *Assas Law Sch.*

You are facing a [little] force. Make sure you unleash the civil war through your resistance (!) *Stairway C. 2nd fl. Nanterre*

The walls have ears. Your ears have walls. *Sciences Po*

There's no [(time to write!!!)] *Stairway C. 2nd fl. Nanterre*

Anarchy is I. *Entrance side A1. Nanterre*

Millionaires of all countries, unite, the tide is turning. *Censier*

Put a cop under your tank.[2] *Censier*

Enjoy without restraint.
Live without dead time.
Fuck without carrots. *Elevator. Cité U. Nanterre*

Grandpa, grandmob. *Censier*

Liberty is the right to silence. *Censier*

We're rats (perhaps) and we bite. The enragés. *Sorbonne*

Stop being bored! Bore into them! *Hall C. 1st fl. Nanterre*

Stop letting yourselves be / registered / filed / oppressed / requisitioned / preached to / inventoried / surveyed / *Stairway foyer. Odéon*

At Nanterre, as elsewhere, the enragés are a pain in your ass "illustrated catalog forthcoming." *Hall. Grand Amphi. Sorbonne*

Did you know Christians still exist? *Hall. Grand Amphi. Sorbonne*

Exaggeration is the mother of invention. *Censier*

We refuse to be / ... rehabilitated ... /

... Public-sectored ... / GRADUATED ... / REGISTERED ... /
yes, or we'll
all be

INDOCTRINATED ... / SUBURBANIZED ... / LECTURED /
yes but through
the Revolution

BEATEN ... / TELEMANIPULATED ... / GASSED
stick-staggered yes, through a TV of our own I love the violet

PUT ON FILE... /
exploited

2nd fl. foyer. Odéon

11

Fire fulfills!! *Building C 4th fl. Nanterre*

Our hope can only come from those without hope. *Sciences Po hall*

Be brief and cruel cannibals! *Music Amphi. Nanterre*

Let's join in the sweeping. There are no maids here. *Beaux-Arts*

I love you!!! Oh, say it with cobblestones!!!!! *Hall A1. Nanterre*

Let's leave
The unforgettable! *Room C 20. Nanterre*

I don't like writing on walls

Music Amphi. Nanterre

I want to talk to you about the University of Salamanca. In 1584 this university had over 75 chairs and nearly 7,000 students. It's true that in 1812, after the war, only 42 remained. In Salamanca there were renowned profs. Fray Luis de Léon. Another more famous prof in France is Miguel Unamuno. Victim of Franco's hordes. In the 16th century it was already close to a democracy.

The profs are elected by the students, the profs elect the commissioner of education who holds the position only for a year.

In the case of an offense the student was judged by the university.

Students, after this dignified revolt you must go further! *Salut.*

You don't beg for the right to live, you take it.

Nanterre

14

Liberty is not a good we possessed. It is a good they've prevented us from having thanks to laws, rules, prejudices, ignorance, etc. ... *Nanterre*

We can't let careerist politicians and their muddy demagogy take over. We can only count on ourselves. Socialism without liberty is a barracks (Bakunin) Revolutionary Anarchist Org. *Nanterre*

France for the French. Fascist slogan.
(Cf. Chant des croix de Feu. Chorus: We want France French.)[3]

Sciences Po hall

The aggressor is not the one who revolts but the one who maintains.

Nanterre

No dialogue with our truncheons. *Nanterre*

I yell
I write
n. 595 378 822 334a of the anonymous bondage. *Oriental Languages*

JCR 8:00 June 5. Grand Amphi. of the Sorbonne.
Imp. meeting
May 68. Agenda: the worldwide revolution. *Sciences Po hall*

Pacifists of all countries defeat all war enterprises by becoming citizens of
the world. *Science Hall. Sorbonne*

Chaplin!
We are no longer calves.
We no longer beleef in our general.[4] *Sorbonne*

All reformism distinguishes itself through the Utopianism of its strategy
and the opportunism of its tactics. *Main Hall. Sorbonne*

Rain.
Rain and wind and carnage shall not disperse us but unite us.
Committee of Cultural Agitation. *Science Hall. Sorbonne*

Enough churches. *Boul. Saint-Germain*

Sorbonne School Street = School of the street.
And what if we burned down the Sorbonne? *Science Hall. Sorbonne*

When the finger points to the moon, the IMBECILE looks at the finger.
Chinese proverb. *Music Conservatory*

In the Revolution, there are two types of people: those who make it, and
those who profit by it. Napoléon. *Music Conservatory*

Reform without Bolsheviks. *Stairway E. Nanterre*

I'M STUPID. *Room C 20. Nanterre*

Those who are afraid will be with us if we remain strong.

Grand Hall. New Sch. of Medicine

We want a wild and ephemeral music.
We propose a fundamental regeneration:
 concert strike
 sound meetings: collective investigation meetings
 suppression of royalties, sound structures belong to everyone.

Music Conservatory

Conservatism is synonymous with rot and ugliness.

Grand Hall. New Sch. of Medicine

Let's open the doors
of the asylums
the prisons
and other
Schools. *Music Amphi. Nanterre*

If you want to avoid the pits, stay clear of moles. *New Sch. of Medicine*

Watch out: careerists and kiss-asses can disguise themselves with a
"sociologist" mask. *La Feuille. Sorbonne*

I declare a state of permanent happiness. *Stairway. Sciences Po*

Mob at play.
March 22 *Sciences Po*

You're asking for self-management? Start with self-ownership.

Stairway. Sciences Po

To be free in 1968 is to participate. *Stairway. Sciences Po*

The barricade closes the street but opens the way.
The CAs May 3. *Censier*

I have something to say but I don't know what. *Censier*

Don't make a will before dying for an ideal, make a kid worthy of his father. "To a talkative father, an active son!" *Sorbonne*

O kind sirs of politics you hide behind your glassy eyes a world on the path to destruction. Scream, scream, it still needs to be known you've been castrated. *Humanities. Sorbonne*

I saw that in history you had the right to revolt provided you risked your life. J. Vallès. *Humanities. Sorbonne*

The infinite has no accent. *New Sch. of Medicine*

In the caverns of order our hands shall forge bombs.

CACR Galerie lettres. Sorbonne

A man is not stupid or intelligent: he is free or he isn't. *Medicine*

Press yourself against the window. Rot among the insects. [It's so sad to love loot.] *Hall B. Nanterre*

Under the paving
stones,
the beach …

Sorbonne

Political power: organization of spatiotemporal survival (Socrates).

Nanterre

Political power is not an *indefensible* right of Gaullism. *Assas Law Sch.*

For a democratic school in a classless society
For a classless school in a democratic society. *Buffon School courtyard*

From here on there will only be two categories of men: those who make revolution and those who shun it.
In the case of marriage, that will make revolushunaries. *Reform School*

Mao Tse-tung Wan Wan Suyn
(May he live 2,000 years!) *Buffon School courtyard*

We'll have a good master the moment everyone becomes their own.
Sciences Po hall

Take the trip everyday of your life. *Stairway C. 3rd fl. Nanterre*

All power exploits.
Absolute power exploits absolutely. *Stairway C. 3rd fl. Nanterre*

They never get tired of seeing servicemen. *Stairway C. 1st fl. Nanterre*

From a man, they can make a cop, a brick, a para-, and they couldn't make a man? *Music Amphi. Nanterre*

Make love
Not war. *Building C. 3rd fl. Nanterre*

Long live Babeuf! *Sorbonne*

Comrades you're nitpicking. *Music Amphi. Nanterre*

Bourgeoisie of France, don't think your sweet tranquility has returned, don't think the "parenthesis" has closed, the régime has a reprieve.
 Sciences Po hall

"One doesn't enter into politics innocently." Saint Just. *Sciences Po hall*

The state (of war) is me. *Richelieu Hall. Sorbonne*

This is a spectacle of opposition. Let's oppose the spectacle. *Sorbonne*

NOTHING. *Censier*

A revolution that demands your sacrifice is a lazy revolution. *Medicine*

Fuck happiness.
[Live] *Sorbonne*

I came.
I saw.
I believed. *Sorbonne*

Politics takes place in the street. *2nd fl. Sciences Po*

Green night
of the barricades ...?
Green or red or blue or black night
What does it matter comrades?
The hope for victory!
That's what matters comrade!!! *Richelieu Hall. Sorbonne*

No one will understand if they don't respect, while retaining their own
nature, the free nature of others. *Censier*

Rome ... Berlin ... Madrid ... Warsaw ... Paris. *Library hall. Sciences Po*

All teachers are taught. All taught are teaching. *Library hall. Sciences Po*

The Revolution must take place in men before it can be realized in things.
Sorbonne courtyard

I'm playing. *Room C 20. Nanterre*

Invent new sexual perversions.
[I can't anymore!] *In front of cafeteria hall C. Nanterre*

We will destroy from the outside they will destroy it from the inside.
OSPAAL.
International solidarity with the African-American people.

Sorbonne courtyard

Amnesty: act by which sovereigns usually pardon the injustices they've
committed. *Sorbonne*

I'm high/Hashish. *Elevator. Building GH. Nanterre*

The US will defeat the marines. *Elevator. Cité U. Nanterre*

Logic is the means of expression. *Elevator. Cité U. Nanterre*

Arm yourselves comrades! *Elevator. Cité U. Nanterre*

Long live the city united-to Cytherea.[5] *Elevator. Cité U. Nanterre*

Long live the holy war against the 5th. *Elevator. Cité U. Nanterre*

Alienation ends where yours begins. *Elevator. Building GH. Nanterre*

To be reactionary is to justify and accept reform without making
subversion thrive on it. *E. S. Saint-Louis*

Childishness is the shame of men facing life at the end of nothingness.

Censier

Comrades, love is also made at Sc. Po, not just in the fields.

March 22 Mvt. Sciences Po hall

Long live the prerevolutionary reactor. *Elevator. Building GH. Nanterre*

Stupidest prof contest
So sign your exam questions *Sorbonne courtyard*

Permanent and cultural vibration. *Buffon School courtyard*

For extraordinary situation
Extraordinary measure
And sacrifices in proportion *Censier*

Down with the summary
Long live ephemerality
 pessimistic Marxist youth *Sorbonne courtyard*

Civic committee seeks clear consciences for denouncement.

Assas. Law Sch.

In the spectacular setting, the gaze encounters only things and their price.
Elevator. Building GH. Nanterre

General unemployment before military service.
"Hoodlums" are the product of the system.
Don't dissociate yourself.
There will never be too many gravediggers for capitalism.

Sciences Po hall

Long live Bonnot. *Nanterre*

Liberate! Franche-Comté. *Nanterre*

Down with orders. *Sorbonne*

Liberate yourself from the Sorbonne. (Burn it.) *Sorbonne*

Prohibiting prohibited. Freedom begins with a prohibition: that of interfering with the freedom of others. *Sorbonne*

No exams. *Sorbonne*

Art is dead. Godard can't do anything about it. *Sorbonne*

The reflection of life is only the transparency of experience. *Sorbonne*

Kill the bureaucrats. Enough action, words. *Sorbonne*

Boredom sweats. *Sorbonne*

A single nonrevolutionary weekend is infinitely bloodier than a month of permanent revolution. *Oriental Languages*

Alert.
Drowsiness lies in wait for Sciences Po.
Let's accept the responsibilities we've taken on.
Let's all participate in the committees that are "stagnating."
Let's call together our meetings.
Let's wake up the council, which is snoring.
Let's support the joint committee and demand more publicity from it.
May the abstainers and the indifferent awake. The action continues.

Sciences Po hall

If you have to resort to force, don't straddle

the fence

Sorbonne

Burn *Le Figaro*. No! The école normale. *Sorbonne*

Don't liberate me I'll take care of it. *Elevator. Building GH. Nanterre*

My thought is not revolutionary if it doesn't involve everyday actions in the framework of education, family, and love. *Reform School*

There is no evil if neither your conscience nor that of any others says there is evil. Marcel Mauss. *Rue Saint-Louis-en-l'Isle*

The Sorbonne will be the Stalingrad of the Sorbonne.

Richelieu Hall. Sorbonne

The barricade is the surest indication of revolutionary blossoming. Thorez. June 1931. Barricades of Roubaix. *Richelieu Hall. Sorbonne*

They're on strike. *Censier*

Stop getting annoyed. Be annoyifying. *Censier*

It took him three weeks to announce in five minutes that he was going to begin in a month what he hasn't managed to do in ten years.

Grand Palais

Fuck each other or they'll fuck you. *Richelieu Hall. Sorbonne*

The commodity, we'll burn it.

Situationist International. Richelieu Hall. Sorbonne

Pay attention to your ears, they have walls. *Censier*

The Revolution is unbelievable because it's real. *Censier*

With Capitant.
Capitant: "Being finally unable to resolve to place my confidence in the ministers whose errors have put the government and General de Gaulle in danger, I find myself forced to turn in my resignation as member of the French National Assembly." *Sciences Po hall*

No social-democratic vapidity. *Censier*

Ballot mallet.[6] *Censier*

The mind progresses more than the heart but goes less far. Chinese
proverb. *Sorbonne*

"Better a dreadful end than dread without end. It's the police testament of
every dying class." Marx. *Richelieu Hall. Sorbonne*

Long live the students of Warsaw. *Elevator. Cité U. Nanterre*

The city whose prince

is a STUDENT ...

14 rue de Condé

Don't take the elevator, take power. *107 avenue de Choisy*

In any case no regrets! *Censier*

Provided they give us time ... *Censier*

The students are idiots!
Oh! That's not true. *Censier*

Heraclitus returns. Down with Parmenides.
Socialism and liberty. *Richelieu Hall. Sorbonne*

You are hollow. *C. 24. Nanterre*

Election campaign.
Dopes
believers
votes.[7] *Richelieu Hall. Sorbonne*

Stay strong. Continue the strike. Occupy the premises. CNJM
If I think nothing should change, I am an idiot.
If I don't want to think, I am a coward.
If I think that it's in my interest nothing changes, I am a swine.
If I am an idiot, a swine, and a coward … I am for de Gaulle.
All repro rights granted save for *Figaro*.

Grand Hall. New Sch. of Medicine

In the past, we only had the poppy. Today, the paving stone.

C. 24. Nanterre

I have nothing to say. *Censier*

You will all end up croaking from comfort. *Grand Amphi. Hall. Nanterre*

We're not there to be bored.
Urbanism, cleanliness, sexuality. *Grand Amphi. Hall. Nanterre*

Mandarin is in you. *Grand Hall. New Sch. of Medicine*

The tears of the Philistines are the nectar of the gods.

Grand Amphi. Hall. Sorbonne

SISYPHUS! ...

Censier

We will demand nothing.
We will ask for nothing.
We will take.
We will occupy. *Grand Amphi. Hall. Sorbonne*

Reform makes a sucker of every grind. *Pharmacy*

See on these walls sexual repression and the refusal of oneself.
(Down with obscurantism.) *Censier*

We must systematically explore chance. *Censier*

Action must not be a reaction but a creation. *Censier*

Independence is the first condition for dialogue with men.
My self-criticism is ossified by this fact, this problem no longer arises.

Censier

All things considered from the viewpoint of the lookout and the sniper,
I am not displeased that shit rides a horse. René Char. *Censier*

We have to pave the tear-gassers! *Censier*

Motions kill emotion. *Censier*

Revolution is not a spectacle for English scholars.

Hall C. 1st fl. Nanterre

The defacing of this *bourgeois* faculty's material is the expression of
revolutionary art.
Asshole. *Hall D. Nanterre*

It is because property exists that there are wars, riots, and injustices. Saint
Augustine. *New Sch. of Medicine*

Enjoy yourself here and now. *New Sch. of Medicine*

The forest precedes man, the desert follows him.

Grand Amphi. Hall. Sorbonne

Run comrade, the old man is behind you. *Grand Amphi. Hall. Sorbonne*

Look at your job, nothingness and torture take part in it.

Grand Amphi. Hall. Sorbonne

Let's not change employers, let's change our employment of life.

Sorbonne

A mere nothing can be a whole, you have to know how to see it and sometimes to make do with it. *Music Amphi. Nanterre*

We are witnessing a change of direction in the struggle of the proletariat, the workers decide at the base, the unions compete with each other to preserve a decision-making power which has until now always forestalled revolutionary awakening. *Building C. 4th fl. Nanterre*

Alligo-Kamikaze, long live the out of sync. *Hall B. Nanterre*

Action institutes consciousness. *Elevator C. 2nd fl. Nanterre*

Imagination is Elsewhere. A. Bret. *C. 20. Nanterre*

Do Gaullists have one too many chromosomes?
Grand Hall. New Sch. of Medicine

Every act of submission to the force external to myself rots me away as
I stand, dead before being buried by the legitimate gravediggers of order.
Hall. New Sch. of Medicine

Bastard
You could at least
Wash your wall. *27 rue Gay-Lussac*

We're reassured. 2 + 2 no longer makes 4. *Hall Censier*

Down with the parliamentary objectivity of the grouplets.
Intelligence is on the side of the bourgeoisie.
Creativity is on the side of the masses.
Stop voting. *Richelieu Hall. Sorbonne*

If you continue to shit on the world, the world will vigorously respond
in kind. *Prof. room. 1st fl. Nanterre*

Don't make a revolution in the image of your confused and ossified
university. *Richelieu Hall. Sorbonne*

As language is the form of social relations between individuals which is
formed under the constraint

1. of natural alienation,
2. of strictly social alienation,

there is no reason not to blow it up at the level of grammatical
repression; ever since Dada made its fuss, literature has done nothing but
rehabilitate it.

Hall E. Nanterre

Hey Bastié, are you kidding? *C. 24. Nanterre*

In *crozier*, we again find our old enemy full of metaphysical subtleties: the commodity. *C. 24. Nanterre*

If your heart is on the left, don't leave your wallet on the right.
Arcades. Pharmacy

Liberties are not granted, they're taken. Charles Maurras.
Sciences Po hall

Gas-soaked rag + soap powder + soil + fuse = Molotov cocktail.
Elevator Cité U

Touraine, or non-transcendence become unbearable. *C. 24. Nanterre*

A thought that stagnates is a thought that rots. *Sorbonne*

No more despotism
 No to
 supplementary
 secondary school
 additional
 special
 supernumerary
 remedial
 classes
No more notice board robbery. *École des Chartes*

Pharma is not hanging by a thread but by your presence. *Pharmacy*

"What we need is an enthusiastic but calm frame of mind, and inner but well-ordered activity." Môa. *Pharmacy*

At Paris after Lamartine
And Hugo even Eugène
Had not thought of it
To weep
There's only tear gas. *Censier*

Exam = servility, social advancement, hierarchical society. *Censier*

The restraints imposed on pleasure excite the pleasure of living without restraint

Elevator. Building GH. Nanterre

I am in the service of no one, the people will serve themselves.

Sorbonne

We've only made the insurrection of our revolution. *Sorbonne*

Neither robot nor slave. *Censier*

The emancipation of man will be total or it will not be. *Censier*

Put your kids in daycare and follow the work of the fac.

Entrance E. EO3. Nanterre

COMMUNIQUÉ.

Louis Terrenoire at the Assembly gallery quoted Charles Péguy.
"Hope gleams like a wisp of straw ..."
We inform the population that Paul Verlaine wrote:
"Hope gleams like a wisp of straw *in the cowshed.*"
Another blunder!

Committee for Cultural Agitation. *Gallery of the Sciences. Sorbonne*

The unions are brothels. *Hall. Grand Amphi. Sorbonne*

We are all German Jews

Hall. Grand Amphi. Sorbonne

A HISTORIC APPEAL

At this time when the French State is being shaken up by the rebellion of its youth, the nationalities oppressed by this State have a real opportunity to cast off the yoke: Bretons, Alsatians, Catalans, Flemish, Basques, West Indians, Corsicans, Occitans, natives of Réunion, and especially the youth of these oppressed ethnic groups can in freeing themselves also contribute to the emancipation of French youth. *Sorbonne courtyard*

The underworld is us.
Severity toward great men is the mark of a strong people.
(Plutarch.) *Sorbonne*

We are all "undesirables"

Beaux-Arts

Love one another on top of each other. *Censier*

Comrades, the legitimate revolution grants amnesty to all the militaries of
the country and asks that they put themselves at the service of the people.
 Richelieu Hall. Sorbonne

The Resistance organizes itself on pure fronts. *Beaux-Arts*

Advocatus diaboli.
From the bottom of my heart I hate the tomb of the great lords and priests
but even more the genius who associates with them. Hölderlin.
 Richelieu Hall. Sorbonne

Death to the half-hearted. *Censier*

SEX.
It's fine, said Mao, but not too often. *Censier*

Comrades.
Enough applause the spectacle is everywhere. *Music Amphi. Nanterre*

"The Difficult is that which can be done immediately; the Impossible that which takes a little longer." G. Santayana. *Sciences Po hall*

Novelty is revolutionary, truth as well. *Censier*

Fire in the belly. *Sorbonne*

Watch out! Pompidou is overtaking us on the left. *Assas Law Sch.*

Have you noticed the similarity in the way the profs and the mandarins dress: it's not all they have in common. *Assas Law Sch.*

The *Revolution* of Ideas will always reverse the *Commune* of thought. 17 will always reverse 71. A. Breton. *Assas Law Sch.*

ANYTHING
ESTABLISHED
AS A SYSTEM

Nanterre

Comrades! Do think of me. (Emile Zola.) *Rue Descartes*

Hurry! *Collège de France*

Imagination is not a gift but above all an object of conquest. A. Breton.
Condorcet

Art doesn't exist.
Art is you. B. Péret. *Condorcet*

Long live de Gaulle. (A masochistic Frenchman.) *Condorcet*

Meddle in affairs of state. Mao Tse-Tung. *Music Conservatory*

"Ideologically penetrate the working class."
[Who's going to get fucked?] *Censier*

Blackmail them by threatening happiness. *Saint-Jacques Sch. of Law*

A cop sleeps in each of us, we must kill him. *Censier*

Those who lock their doors are cowards thus enemies. *Censier*

**The Bourgeoisie
have no pleasure
other than degrading
themselves**

Assas Law Sch.

And I repeat: a third is worth nothing, take everything (and the rest).
Grand Hall New Sch. of Medicine

I don't know what to write but I'd like to say something stupid and I don't know. *Censier*

Is to be rich to be content with one's poverty? *Censier*

When I grow up I'm gonna be a cop. *Censier*

I like riting in funetics. *Censier*

Already 10 days
of happiness

Censier

The economy is wounded,
let it die

Censier

Open the windows of your heart. *Censier*

We want to smash. *Sorbonne*

"The state has a long history, and one that is full of blood." Clemenceau.
Sorbonne courtyard

Your boss was at the Concorde to defend his freedom; the Gaullist gangs
are ready to guarantee your freedom to be exploited, when the boss is free
the factory is a penal colony. CA Committee *Saint-Louis-en-l'Isle*

Alcohol kills. Take LSD *Elevator Bldg. Cité U. Nanterre*

All reactionaries are paper tigers. *Elevator Bldg. Cité U. Nanterre*

When I hear the word "culture" I reach for my CRS.[8]

Stairway C. 2nd fl. Nanterre

Long live rape and violence!
[No]
[Yes] *Room C 20. Nanterre*

Speeches are counterrevolutionary. *Hall 13. 1st fl. Nanterre*

Be salty, not sweet!

Odéon

"See Nanterre and live."
Go die in Naples with the Club Méditerranée. *Music Amphi. Nanterre*

You can't erase the truth (nor lies for that matter). *Room C 20. Nanterre*

Who speaks of love destroys love. *Room C 20. Nanterre*

To shout death is to shout life. *Room C 20. Nanterre*

Student power. *Arcades. Pharmacy*

The Revolution is an INITIATIVE. *Odéon*

The proletariat are those who have no power over the use of their lives
and who know it. *Censier*

Help us out.
We don't want to see your children in prison. *Rue Saint-Louis-en-l'Isle*

Everything begins in mysticism and ends in politics. Péguy.
Hall. Grand Amphi. Sorbonne

"You're laughing at us? You won't be laughing for long."
addressed to the Committee of the Saint-Antoine District at the
Convention. 1793. *Nanterre C 24*

Power isn't taken, it's gathered up. For the anniversary of the appeal of June 18, we'll shovel up de Gaulle.[9] *Sorbonne*

It's not man, but the world that's become abnormal. A. Artaud.
Music Amphi. Nanterre

That which cannot be conceived through another THING must be conceived through ITSELF. Spinoza. *C 20. Nanterre*

I'm Marxist with groucho leanings. *C 20. Nanterre*

If you think for others, others will think for you. *C 24. Nanterre*

To the great scandal of some, under the scarcely less severe eye of others, lifting its weight of wings, your liberty. A. Breton, Ode to Ch. Fourier.

Room C 20. Nanterre

The wind is rising, we must try to live. *Room C 20. Nanterre*

Beautiful, maybe not, but oh how charming.
Life versus survival. *Room C 20. Nanterre*

The old mole of history appears to be burrowing away under the Sorbonne.
Telegram from Marx, 13 May 68. *Sorbonne courtyard*

Be realists
demand
the impossible

Censier

Idleness is now a crime
yes but at the same time a right. *Censier*

Bourgeois, social climbers who pull the ladder up after them and don't
want to let the people climb it. Victor Hugo. *Hall. Grand Amphi. Sorbonne*

The gavroche committee—revolutionary. *Gallery of the Sciences. Sorbonne*

Strip letters naked
You'll have Being. *Censier*

The removal of cobblestones from the streets is the starting point for the
destruction of city planning. *Hall. Grand Amphi. Sorbonne*

Get enraged!

Music Amphi. Nanterre

The young make love
the old make obscene gestures.
Who are the pigs who dare write on walls? *Condorcet*

We're not denying you the possession of your intelligence, but at a
minimum the use you put it to. *C 24. Nanterre*

Respect is lost, don't go looking for it. *Condorcet*

In the land of Descartes, bullshit gets carded. *Condorcet*

Trique-olored government.[10] *Reform School. Saint-Louis-en-l'Isle*

Minions of thought, professionals of fear, do you think that a free man won't cut down your trees in front of your rabbit hutches, that he won't steal your women when you love them badly. That his insults won't tarnish your dignity when you continue to exude your venom at your slave's anguish. Son of an assoc. prof. *New Sch. of Medicine*

You don't compromise with a society in decay.

Hall. Grand Amphi. Sorbonne

Break the windows fuck the widows. *Stairway C 2nd fl. Nanterre*

No patching up, the structure is rotten. *Assas Law Sch.*

Liberty is the crime that contains all crimes
it's our ultimate weapon

Hall. Grand Amphi. Sorbonne

Power had the universities
the students took them over.
Power had the factories
the workers took them over.
Power had the ORTF
the journalists took it over.
Power has Power
Take it. *Entrance hall. Sciences Po*

Comrades, be sure to keep the premises clean.

Reform School. Saint-Louis-en-l'Isle

Add up your resentment and be ashamed. *Censier*

Free love. (But not here!)
Why?
Everything here is made for alienated love. *Building G and H. Nanterre*

There is no Revolutionary thinking.
There are only Revolutionary acts. *Building C. 4th fl. Nanterre*

Action allows divisions to be overcome and solutions to be found.
Action is in the street. *Entrance hall. Sciences Po*

Watch out, comrades, the republican order is going to reestablish itself.
A defeatist. *Science Hall. Sorbonne*

90

Professors you're as old as your culture, your modernism is just the modernization of the police.
Culture is in pieces (the enragés). *Hall. Grand Amphi. Sorbonne*

Hope: don't despair, let steep longer. *Sorbonne courtyard*

Forget everything you've learned.
Start by dreaming. *Sorbonne*

Unbutton your mind as often as your fly. *Odéon*

The State is each one of us. *Quai Malaquais*

HIDE,

OBJECT

Richelieu Hall. Sorbonne

Don't rule out the passive. *Arcades. Pharmacy*

He's the disorder. *Pharmacy*

Alone we can't do anything. *Arcades. Pharmacy*

Have ideas. *Arcades. Pharmacy*

Here we think. *Arcades. Pharmacy*

May the cork pop and liberate the revolutionary energy of the masses!
 Galerie Lettres. Sorbonne

Write everywhere!
Reply: "Before writing, though, learn to think." *Rue de l'Echaudé*

"Every view of things which is not strange is false." Valéry.

Galerie Lettres. Sorbonne

80% vote, 5% take part in the reform. *Arcades. Pharmacy*

The enemy of the movement is *skepticism*.
Everything that has been realized arises from the *dynamism* that follows
from *spontaneity*. *Oriental Languages*

Oh truly unnatural Mother Nature. *Cour Etats Généraux Cinema*

Borders = repression.	*Beaux-Arts*

Free information!	*Beaux-Arts*

Contingency won't be a scab.	*Beaux-Arts*

To give in a little is to surrender a lot.	*Beaux-Arts*

No to the Revolution in a suit and tie.	*Beaux-Arts*

The hard reality of the cobblestone "a CRS."	*Hall. Grand Amphi. Sorbonne*

EVE

Nanterre

The most beautiful sculpture is made of sandstone.
The critical heavy cobblestone is the cobblestone you hurl at the face
of the cops. *Hall. Grand Amphi. Sorbonne*

The outcome of every thought is the cobblestone. *Sorbonne*

Program = private property for the future. *Richelieu Hall. Sorbonne*

Speak for whom?
How can we get from *speaking* to *doing*? *Entrance hall. Odéon*

The act is spontaneous and bears within it the realization of the other.
Entrance A1. Nanterre

The Revolution must cease to be

in order to EXIST

Hall A1. Nanterre

Who creates? For whom? *Stage fire curtain. Odéon*

Are you consumers or are you participants? *Stage fire curtain. Odéon*

Place for speech or place for alienated chatter? *Stage fire curtain. Odéon*

Solitary at first then solidarity at last. *Stage fire curtain. Odéon*

Look them straight in the face!!! *Corridor. Odéon*

When the national assembly becomes
a bourgeois theater
all the bourgeois theaters need to become
national assemblies

Entrance hall. Odéon

The Revolution isn't just that of the committees but first and foremost yours. *Stage fire curtain. Odéon*

Don't insulate your acts!!! *Corridor. Odéon*

Worker: you're 25 years old but your union is from another century. To change this, come see us. *Corridor. Odéon*

Don't throw things on the ground, the ex-Odéon hasn't turned into a garbage dump. *On the doors of all the boxes. Odéon*

Prejudices are the stilts of civilization. (Gide.) *Foyer. Odéon*

The golden age was the age when gold didn't reign. The golden calf is always made of mud. *Foyer. Odéon*

My aim is to agitate and disturb people. I'm not selling bread, I'm selling yeast. (Unamuno.) *Corridors. Odéon*

We don't want to be testators. *Institute of Psychology*

To challenge the society in which we "live" we must first be capable of challenging ourselves. *On the kitchen mirror. Odéon*

Everything is Dada. *Foyer. Odéon*

Embrace your lover

without dropping your rifle

Odéon

Look at yourself: we're waiting for you! *Odéon*

Make love and start over. *Odéon*

Let's take the Revolution seriously but let's not take ourselves seriously.
Odéon

We want: structures at the service of man and not man at the service
of structures. We want to have the pleasure of living and an end to the
displeasure of living. *Odéon*

Live in the present. *Odéon*

No to induced abortion, yes to intelligent contraception.

Entrance hall. Odéon

CRS visiting in civvies, be sure to mind the step on your way out.

Entrance hall. Odéon

Abolition of the right to vote with retirement.

Arcades, rue Corneille. Odéon

We're lacking vitamin C. *Facade. Odéon*

Art is shit. *Rue Rotrou. Odéon*

*Young red women
always more beautiful*

Grand Hall. New Sch. of Medicine

CRS you can quit your job here. *Entrance hall. Odéon*

One must still have chaos in oneself to give birth to a dancing star
(Nietzsche). *Stairway hall. Odéon*

All power to the worker's councils. *Facade. Odéon*

Run, comrade, the old world is behind you. *Rue Rotrou. Odéon*

The arms of critique undergo the critique of arms. *Rue Rotrou. Odéon*

If you want to be happy hang your landlord. *Rue Rotrou. Odéon*

Power over your life you get from yourself. *Rue Rotrou. Odéon*

Joint management = crisis. *Rue Rotrou. Odéon*

Referendum = voting for your ball and chain. *Rue Rotrou. Odéon*

Coup d'etat, please. *Arcades rue Corneille. Odéon*

Reform my ass. (According to Queneau.) *Room C 20. Nanterre*

SOT
SCEAUX
SEAUX
CEAUX
SOT
SO[11]

Stairway C. Nanterre

Wherever death may surprise us, let it be welcome so long as our battle cry has reached even one receptive ear and another hand reaches out to take up our arms, and other men arise to sing funeral laments against the crackling of machine guns and new battle cries of war and victory. Che!

Music Amphi. Nanterre

Realize the power of the Worker's Councils! J. R. (Revolutionary Youth Movement). *Room C 20. Nanterre*

Plebiscite: whether one says yes or no it makes us idiots.

Arcades, rue Corneille. Odéon

Zone of unreality. *At an access control point. Hall A. Nanterre*

All power to the free Soviets. *Rue Corneille. Odéon*

Referendum = new taxes *to make us pay for damages*. *Rue Rotrou. Odéon*

Referendum: a dodge then dictatorship. *Arcades, rue Corneille. Odéon*

"Conflict is the father of everything." Heraclitus. *Nanterre*

Warning school molting. *School porch of Chartres*

Claudel never again. *Hall E. Nanterre*

We had but 1 way of escaping the false situation the law had created, and that was to break it. Tolain. *Building C. 4th fl. Nanterre*

There's a method to their madness. Hamlet. *Building C. 4th fl. Nanterre*

The sacred, that's the enemy. *Hall B. Nanterre*

Dare.
This word encompasses all politics right now. Saint-Just to the National Convention! *Nanterre*

Liberty of the university.
No to totalitarianism.
Committee of Students for University Liberties. *Sciences Po hall*

For the Minister's meal:
Truffled pig.
Smoked Anar brains.
Foie de grenades.
Cobblestones on barricades.
Grilled Provos.
Enragé soufflé.
Unlimited sparkling water. *Nanterre*

115

In the schools
6% workers' sons

in the rehabilitation schools 90%

Rue Saint-Louis-en-l'Isle

With the direct distribution of chickens, potatoes, etc. … we have the intersection of the worker's struggle and the farmer's.

Hall D. 1st fl. Nanterre

To be revolutionary is first to maintain permanency and reception. After which intellectual masturbation is permitted. *Rue Saint-Louis-en-l'Isle*

More than ever action committees.
First and foremost action committees.
Victory thanks to the action committees.
Do you have your action committee.
If not create your action committee. *Sorbonne courtyard*

Mortality, temporality, limitations and exclusivity are only possible through organization and structures. *Hall A1. Nanterre*

No to news. J.M.P. *Room C 20. Nanterre*

I'm a pain in Society's ass, but it's mutual. *Condorcet*

Happiness is a new idea at Sciences Po. *Entrance. Sciences Po*

For sale
Leather jacket. Demonstration special guaranteed anti-CRS. Size large, price 100 F. *Buildings G and H. Nanterre*

Black Power to tame Whites.

Side wall, rue Saints-Pères. New Sch. of Medicine

Neighborhood residents, be vigilant. As of Tuesday the Government wants work to resume by all means possible. Help the strikers and peacefully demonstrate your solidarity by your presence near their place of work first thing in the morning. *Entrance hall. Odéon*

The new society must be founded on the absence of all egoism, of all egolatry.
Our road will become a long march of brotherhood.

Library hall. Sorbonne

Naked on the 6th floor. *Elevator. Cité U. Nanterre*

Long live the living theater. *Music Amphi. Nanterre*

Permanent recess. *Buffon School courtyard*

Permanent protest. *Library hall. Sciences Po*

Red for being born in Barcelona.
Black for dying in Paris. *Censier*

Citizen rhymes with Fascism. *Music Conservatory*

Protest the Administration with us. 10 years now with no assessment nor responsibility in self-dissatisfaction. *Assas Law Sch.*

Down with socialist realism. Long live surrealism. *Condorcet*

God is a scandal, a profitable scandal. Baudelaire. *Condorcet*

Long live the creative masses!
No to the bourgeois lack of culture.
Culture is a fluid. *Condorcet*

My personal freedom, confirmed by the liberty of others, extends mine to infinity. Bakunin. *Condorcet*

1936
last coat
of paint

Condorcet

Learn, learn, and learn in order to act and understand. Lenin.

Condorcet

It's sad to say but I don't think we can win without the red and black flags.
But they must be destroyed—afterward. Jean Genet. *Condorcet*

Light pay
Heavy tanks. *Rue de Seine*

We want our exams.
The Bourgeoisie. *Elevator E. 4th fl. Nanterre*

No liberty for the enemies of liberty. *Elevator E. 2nd fl. Nanterre*

One isn't in love 2% or even 4%. *Sciences Po hall*

There are 38,000 communes in France.
We're in the second. *Library hall. Sciences Po*

We have a prehistoric left. *Sciences Po hall*

The duty of every revolutionary is to make revolution.
 Sciences Po hall, ceiling

Let's dance
THE JIG

Bldg. C. 4th fl. Nanterre

Political freedom. *Sciences Po*

The government had factories, the workers took them over! The *hypo pseudo* government had universities, the students took them over! The hypo pseudo government has nothing but governing left ... we'll take it over!!! *Condorcet*

Civic action.
Inequitable action. March 22. *Sciences Po hall*

I'm at the service of no one (not even of the people and even less of their leaders). *Censier*

Nuisance bureau.
 Screening.
 Debraining.
 Ubu and his Palcontents. *On a door. Condorcet*

Creativity.
Spontaneity.
Life. *Censier*

To lack imagination is not to imagine lack. *Music Amphi. Nanterre*

LEAVE THE FEAR
OF RED
TO HORNED ANIMALS

Beaux-Arts

100 idiots bury me with nary a commentary. R. Daumal.

Oriental Languages

The great torment:
"De G. moans: the workers aren't working, the teachers aren't teaching, the students aren't studying; but we know what's tormenting him the most and it's that which he doesn't say, and it's that the capitalists aren't capitalizing." The Renault/Flins Strikers. *Oriental Languages*

You're occupying your leisure activities at the Sorbonne. You're occupying the Sorbonne at your leisure. *Censier*

Death is necessarily a counterrevolution. *Oriental Languages*

Extraordinary measures
For extraordinary situations
and sacrifice in proportion. *Censier*

I shit on the politiCONS, on the well off, I shit on the Borders and the
privileged. *Oriental Languages*

Post bills. *Sciences Po hall*

We screwed in your sanctuary. The university professors are only the
feeblest objectifications of the great metaphysics (the economy).
C. 24. Nanterre

The general will against the general's will. *Censier*

The Royalists amuse us, the Fascists piss us off! *Condorcet*

You need some red to get out of the black. *Censier*

To fight unemployment, help your archdiocese build new churches.
 Oriental Languages

Life loves the consciousness one has of it. René Char. *Assas Law Sch.*

Anyone who can attach
a number to a text
is an asshole

Hall. Grand Amphi. Sorbonne

Rebellion and Rebellion alone is creator of light, and this light can only be known by way of three paths: poetry, liberty, and love. André Breton.

Assas Law Sch.

We will never forget the class struggle. *Beaux-Arts*

Civic
Indic
Flic[12]
Here freedom ends. *Louis-le-Grand School*

Exaggeration, that's the weapon. *Censier*

Where do correct ideas come from? Do they drop from the sky? No.
Are they innate in the mind? No. They come from social practice and from
it alone. They come from three kinds of social practice: the strugglefor
production, the class struggle, and scientific experiment. Mao Tse-tung.

Beaux-Arts

Down with the spectacular-commodity society. *Beaux-Arts*

An end to the University. *Beaux-Arts*

Down with journalists and those who want to humor them.

Hall. Grand Amphi. Sorbonne

Let's take care of our affairs ourselves (the enragés).

Hall. Grand Amphi. Sorbonne

Rape your
ALMA MATER

Bldg. C. 24. Nanterre

Pull your mind out of this dungeon. *C. 20. Nanterre*

Soon to be charming ruins. *Stairway C. Nanterre*

It's not a question of ignoring fear but of agreeing to see it—at uni—The Government is trying to destroy us. Let's confront it without deluding ourselves. *Grand Hall. New Sch. of Medicine*

There is no Romanticism of Action. There can be no lyrical clichés. Use your Cortex. An objective analysis is needed. To take a stand, to act at the level of facts. A logical reform like a beautiful equation. That isn't enough.
Grand Hall. New Sch. of Medicine

137

Enough laughter! The cops are vigorously rising up against the use of their name to characterize the abuse, sadism, and acts of violence by the forces of repression. And rising up against the exploitation of cows by man, this society of consumption is only able to turn out calves! Reasserting their solidarity with the student movement, having long understood the need for dialogue. Action Committee of the Parisian Dairies.[13]

Grand Hall. New Sch. of Medicine

Nature made neither servants nor masters, I don't want to give or receive laws. *Sciences Po hall*

It's in stopping our machines in unity that we demonstrate their weakness.

Rue de Seine

De Gaulle NO.
Mitterand NO.
Popular Government YES. *Beaux-Arts*

"Blow up your mind." *Elevator 3rd fl. Nanterre*

It isn't just the reason of millennia bursting within us, but their madness, it's dangerous to be an heir. *Nanterre*

What is a master, a god? Both are images of the father and fulfill an oppressive function by definition. *Medicine*

All power
to the

imagination

Stairway. Sciences Po

To build a revolution is also to break all inner chains. *Medicine*

"Claudel is variety theater for the archbishop." (H. de Montherlant.)
Stairway C. 3rd fl. Nanterre

Revolution, I love you. *Music Amphi. Nanterre*

Lucidity is the wound closest to the sun. Don't fall asleep in the shadow of the committees. *Medicine*

Insolence is the new revolutionary weapon. *Medicine*

A revolutionary is a tightrope walker. *New Sch. of Medicine*

Interrupting is not permitted. *Sciences Po hall*

Urgent. Gas for ambulances. *Beaux-Arts*

Man is neither Rousseau's noble savage, nor the Church and La
Rochefoucauld's pervert. He is violent when oppressed, gentle when free.
New Sch. of Medicine

All power to the worker's councils (an enragé).
All power to the enragé's councils (a worker). *Censier*

Talk with your neighbors

Censier

Cemetery. *Ext. wall. Building E. Nanterre*

We don't give a damn about the borders. *Library hall. Sciences Po*

Every Communist must grasp the truth: political power grows out of the barrel of a gun. Mao. *Rue de Santeuil*

Political power is at the end of a gun.
[Is the gun at the end of political power?] *Hall C. 1st fl. Nanterre*

There can only be revolution where there is consciousness.
 Stairway. Sciences Po

Humanity [down with Huma, counter-revolutionary rag] will only live free when the last capitalist has been hung with the guts of the last bureaucrat.
Stairway C. 1st fl. Nanterre

Obedience begins with consciousness and consciousness with disobedience. *Censier*

Let's fight the emotional fixation that paralyzes our potential. CWWL. Committee of Women on the Way to Liberation. *Censier*

Neither master nor God. God is me. *Censier*

Neither god nor meter. *Room C. 20. Nanterre*

I COME
in the cobblestones

Hall A1. Nanterre

Life is a mauve antelope on a field of tuna. Tzara.

Richelieu Hall. Sorbonne

Culture is the inversion of life. *Rue de Vaugirard*

Past days awaken in me
days of songs of the revolution
and a shiver like in times past
my body towers over
 this hallowed land
 of freedom.

Extract of a poem by Yannis Necreponis. *Richelieu Amphi. Sorbonne*

148

Trabajadores Franceses emigrados unidos
Trabahadores Francêses emigrantes unidos. *Sorbonne*

Change life therefore transform its user's manual. *Rue Retrou. Odéon*

Here a bourgeois university was erected. *Exterior. Pharmacy*

In the streets no one has walked, risk your way!
In the thoughts no one has thought, risk your head! *Stairway hall. Odéon*

Live without idle time, enjoy without restraint. *Foyer. 2nd fl. Odéon*

We must condemn profitability, industrial profit, to achieve a socialist consciousness. We must first change the mentality of the masses to achieve a new man. (Che.) *Stairway hall. Odéon*

First contest yourself.
[Yes, even de Gaulle.] *Foyer. 2nd fl. Odéon*

Long live free love. *Foyer. 2nd fl. Odéon*

When the last sociologist is hung with the guts of the last bureaucrat, will we still have any "problems"? *Hall. Grand Amphi. Sorbonne*

Whuts objectivity

Censier

Humanity will only be happy when the last capitalist is hung with the guts of the last leftist. *Condorcet*

An excess of grandeur makes for a lost sense of reality (Charles de Gaulle).
 Nanterre

To desire reality is good! to realize one's desires is better.
 Hall. Grand Amphi. Sorbonne

My desires are reality. *C. 24. Nanterre*

Truth alone is revolutionary. *C. 24. Nanterre*

I take my desires for reality, for I believe in reality.

Hall. Grand Amphi. Sorbonne

Those who take their desires for realities are those who believe in the
reality of their desires. *Richelieu Hall. Sorbonne*

Long live direct democracy. *Stairway. Sorbonne*

Our modernism is only the modernization of the police. *C. 24. Nanterre*

Culture is like jam: the less one has the more one spreads it. *Censier*

Long live the power of the worker's councils extended to all aspects
of life. *Nanterre*

Careful comrade, or we'll liberate the profs from their bad conscience.

Censier

Shame is opposed. *Sorbonne*

Industrialization is threatening us. Rubber nipples make for a carnivorous
society. *Censier*

Nihilism needs to start with itself. *Censier*

Let's not consume MARX

Censier

Those who talk of revolution and class struggle without referring to everyday reality talk with a corpse in their mouth. *Sorbonne*

To reach reality, we must first set aside the lived, set it aside in order to subsequently reintegrate it in an objective synthesis. *Sorbonne*

Are we going to spend our time at the Sorbonne speculating on the Revolution? Or are we going to act in accordance with our words.

Today magnificent struggles are developing in the factories run by the workers. Raised en masse to the factories, the building sites, the shantytowns. "The people, and the people alone are the driving force of history, the creators of world history." Mao Tse-tung. *Censier*

The Sorbonne's city planning produced the generations of eunuchs
we know. *Beaux-Arts*

And yet everyone wants to breathe and no one can breathe and many say
"we'll breathe later." And most of them don't die because they're already
dead. The destroyers. *Nanterre*

Freedom begins with a prohibition. That of interfering with the freedom
of others. *Nanterre*

It's not a revolution Sire, it's a transformation. *Nanterre*

Don't go to Greece
this summer,

stay at the Sorbonne

Sorbonne

Transformation washes whiter than revolution or reforms. *Censier*

May 68: France goes about its business. *Sciences Po hall*

What's a ram? One who breaks down the doors and opens the Sorbonne to everyone. *Sorbonne*

How Zamansky changes an enraged ram into a sheep:
—by castrating you (photo);
—by selecting you (photo). *Censier*

Orthography is a mandarin

Sorbonne

The house is burning and grandma combs her hair. Romanian proverb.

Rue de la Sorbonne

Absence is there where misfortune takes form. *Sorbonne*

The life of presence, nothing but presence. *Sorbonne*

Already a healthy wind is rising from one end of Europe to the other knocking over barriers. (De Gaulle to the University of Bucharest.)

Sorbonne

Careful we're surrounded by assholes. Let's not linger over the spectacle of opposition but move on to opposing the spectacle. *Odéon*

The more I make love, the more I want to make Revolution.
The more I make revolution, the more I want to make love.

(One of the enragés.)

Sorbonne

Kill the bureaucrats. Enough acts—words!

Gallery of the Sciences. Sorbonne

Comrades, 5 h. of sleep out of 24 are essential: we're counting on you for the Revolution. *Odéon*

Car = gadget. *Censier*

The commodity we'll burn it. *Censier*

Proprietors of opinions abstain, no orators, no mike. *Sorbonne*

To the heart of suffering. *Nanterre*

Cleanliness repression

Beaux-Arts

Youth is the spirit of the Old. Mao. *Condorcet*

You too can steal. *Sorbonne*

I don't like work, and love loves the Revolution. (One of the enragés.)
 Nanterre

The prospect of tomorrow's enjoyment will never console me for today's
boredom. *Elevator C. 2nd fl. Nanterre*

Poetry is in the street. *Rue Rotrou. Odéon*

Today masochism takes the form of reformism. *Sorbonne*

The truncheon teaches indifference. *Sorbonne*

People who work are bored when they're not working. People who don't work are never bored. *Sorbonne*

The student's aptitude for being a militant of any sort tells you a good deal about his impotence. The enragé women. *Nanterre*

Art is dead, let's liberate our everyday life. *Sorbonne*

The passion for destruction! is a creative joy. (Bakunin.) *Sorbonne*

Liberty is the consciousness of necessity. *Place de la Sorbonne*

167

Take the breeches
off your sentences
 if you want to be equal
 to the sans-culottes

Sorbonne

When people realize that they're bored they cease to be bored.

Rue Cujas

Fascist dictatorship is those iron rings with which the bourgeoisie tries to reinforce the staved-in barrels of capitalism. *Sorbonne*

Shame is counterrevolutionary. *Nanterre*

One has the right to smoke. Especially hashish (with your responsibility as a nonunionized consumer).

Risk of fire. The government receives 60% of indirect taxes on tobacco!

Sorbonne

Look at yourself, you're sad (The Enragés). *Sorbonne*

Welfare benefits are death. *Sorbonne*

Steal cigarettes and give the direct 40% to the students. The government gets 60% of indirect taxes on tobacco. Liberty ends here. Here and there as elsewhere, let us live. *Sorbonne*

Take part in cultural agitation. *Sorbonne*

The revolution has begun. *Sorbonne*

Down with neo-exotic orientalism! *Oriental Languages*

Life
is elsewhere

Sorbonne

Long live the brats and the louts. *Hall C. 1st fl. Nanterre*

The Odéon is keeping us occupied, we're not occupying the Odéon!

Odéon

I dream of being a happy imbecile. *Music Amphi. Sorbonne*

Long live the enragés who build adventures.

Hall. Grand Amphi. Sorbonne

Those who didn't live in the time before the revolution don't know what the sweetness of living is. *C. 20. Nanterre*

Let the deans dean, the cops cop, and let the revolutionaries make revolution[14]

Censier

afterword

The Posts Have the Floor: Comparing 1960s Protest Graffiti with Digitally Mediated Commentary, Memes, and Play

In the translator's introduction, Henry Vale includes a quick joke from *The Blue Flowers* by Raymond Queneau. "You're just making a lot of fuss about nothing," one character tells a disgruntled fence-painter. "Graffiti, what are graffiti? Simply literature." As this afterword will illustrate, one could easily rephrase Queneau's joke as "You're just making a lot of fuss about nothing … posts on the Internet, what are posts on the Internet? Simply folklore."

This parallel works, first, because of the striking overlap between graffiti and the public commentary, images, and memes—collectively described as online vernacular—that throng social media. It works, second, because in each case the punchline remains the same, for the same

reasons. There is nothing simple about literature or folklore; likewise there is nothing simple about graffiti or online vernacular, whatever form these might take.

Of course, graffiti and online vernacular aren't perfectly interchangeable. At the surface level, their differences are quite obvious. Graffiti, unlike public online expression, is tethered to *place*; it is tangible and localized. Images of graffiti can be reproduced, for example in volumes like the one you hold now. But the graffiti itself—the originals, one could say—can only be experienced in person, from a particular vantage point. Online, the very concept of "original" is fraught, as is the notion of vantage points, as copies of copies of copies of countless, ever-evolving digital artifacts careen across and between online platforms, often rendering untenable the very notions of authorship and fixed location.

The respective tools associated with graffiti and online vernacular are also conspicuously different. Graffiti artists use as their canvas a tactile surface, that is to say, a physical wall they can touch, along with other actual objects capable of transferring actual pigment. On the Internet,

people don't physically touch the digital texts they create. Further, the tools they use are predicated on the affordances of digital media. These affordances include modularity, the ability to take a smaller piece from a larger whole without destroying that whole; modifiability, the ability to alter and/or reconfigure those pieces; archivability, the ability to store those pieces for later; and searchability, the ability to find desired content through search indexing and tagging.

These differences aren't merely descriptive—that is to say, the tools of graffiti look like this, while the tools of digital media look like that. The differences are also proscriptive; they determine what can be done by whom, and further, what the ethical implications of such doings might be. In the case of graffiti, the fact that a painted or sprayed-on message overwrites an existing surface prompts—and in some cases, actively courts—charges of defacement. Something is "ruined"—depending on who might be looking, anyway—thus warranting an institutional response, or at the very least, bystander rubbernecking. These concerns tap into and complicate notions of private property, the public commons, and free speech more broadly

(e.g., you may have a right to your own opinion, but that doesn't necessarily extend to scrawling those opinions on the side of a building).

Online, vernacular expression—even the nastiest, most deliberately destructive—doesn't work like that. Specific websites can be hacked, and their public-facing content altered, but beyond these more traditional articulations of vandalism, digital texts can't be "ruined," at least not in the same ways. You can save something to your computer, and you can adjust it using any number of apps, but the original isn't forever altered as a result. All modifying a copy does is create a different thing.

The ability to make new things out of the old engenders an entirely new set of ethical concerns online, particularly around issues of decontextualization and fetishized sight. When content is unmoored from its original source, when it may be modified by others with a click of a button, when iterations live on through knee-jerk reposting, and anything can be found in five seconds on Google, it becomes very likely, and in fact is almost inevitable, that the full interpersonal, historical, or political context of a given artifact will be lost. As I explain with Ryan Milner in our recent study of online

Afterword

ambivalence (Phillips and Milner 2017), not only does this arrangement set Internet users up to blithely step on other users' toes, it means that often, it's not even clear that there are toes being stepped on. Harm, disruption, and defacement may not be the goal, in other words, but they are often the outcome, even when individuals think they're just posting a funny picture to Twitter. Because of the constant textual zooming, the lack of clear authorship, and the play frames that shift without warning online, there's no such thing as "just" anything on the Internet, a complication specific to, and in fact born of, the tools of digital mediation—tools that simply don't exist in embodied spaces, and therefore simply cannot create comparable ethical concerns.

And so, yes, clearly—there are significant differences between 1960s protest graffiti and today's vernacular expression online. At the same time, there are just as many points of overlap as there are points of divergence, meaning that, as different as they might be, one can still be used to explore and provide insight into the other.

The first connection between graffiti and online vernacular is Poe's Law. As Ryan Milner (2016) explains, Poe's Law—first introduced on a

Creationist message board in the mid-2000s—states that it is difficult, if not impossible, to determine a person's true motives just by looking at what they've said. While Poe's Law is typically used to describe online spaces and behaviors, the broader idea applies whenever one cannot be sure if public commentary is sincere, satirical, or otherwise specious, particularly when the identity of the speaker is obscured (i.e., their message was posted anonymously or pseudonymously) or simply unknown to you (i.e., they are named, but you have never interacted with them).

Granted, the historical, political, and even geographical context of a particular utterance—regardless of era or media—makes some meanings more likely than others. The fact that the graffiti featured in these pages were collected during a period of widespread civil unrest and student protest, for example, suggests with high probability that many, if not most, of the messages reflecting widespread civil unrest and student protest were sincere. Similarly, to take an example from contemporary Internet headlines, much of the cavalcade of anti-Trump commentary, memes, and critiques posted in the wake of whatever latest disaster (Trump

encouraging police brutality in a campaign-style speech to his supporters; Trump equating neo-Nazis with antiracist activists and then professing not to understand the pushback; Trump Friday-night-news-dumping the presidential pardon of a convicted civil rights offender in the middle of a hurricane) likely reflects genuine concerns.

That said, one cannot *exclude* the possibility, certainly not just by observing, that a seemingly sincere message may have instead been motivated by mischief, misinformation, or outright mayhem. Further, when considering especially ambiguous expressions, regardless of era or media, a speaker's true intentions become even more difficult to parse. In this volume, for example, statements like "Did you know Christians still exist?" (p. 10), "When I grow up I'm gonna be a cop" (p. 73), and "I'm stupid" (p. 18), are best met with a raised eyebrow, not certitude.

Another through-line connecting embodied graffiti and digital communication is the fact that, as folklore, these expressions are always a reflection of their broader cultural moment. This insight comes from the ubiquitous American folklorist Alan Dundes (1987), who underscores the fact that one

can extrapolate what is happening culturally from the kinds of things people are saying and doing in public, regardless of whether they say it with paint or say it with a Facebook "like" button. Dundes's insight, which reverberates across the entire discipline of folklore, is one way to wiggle out from beneath the grip of Poe's Law; even if we can't know for sure what someone meant when they decided to publicize a given message, we can know that the choice to do so was in response to broader cultural forces.

Take, for example, the message "France for the French. Fascist slogan" (p. 15), essentially a meta call-response in which the artist was iterating, and then denouncing, the pro–de Gaulle rallying cry "France is for the French." It does not matter if the person who scrawled this message (whose implicit meaning is that "France is for the French" *is* a fascist slogan) really meant what they were saying, or if, instead, they were mocking anyone who would equate "France is for the French" with fascism. Nor does it matter if, to counter with another Trumpian example, people posting some variation of the phrase "Make America Great Again. Fascist slogan" (the more things change …) really mean that atavistic calls to return to the "glory

days" of American culture are inherently fascist, or if they're sneering at those who would make such a claim. Nobody would bother saying either if those sentiments weren't front and center within the public consciousness. Messages such as these thus provide a window onto the broader culture—which, to loop back to the beginning of this afterword, is precisely why graffiti and online postings deserve the mantle of literature and folklore, respectively. They are doing that much cultural work.

The final point of connection between graffiti and online vernacular is the fact that both categories are examples of memetic media. In this instance, "memetic media" is a much more sweeping framing than the comparatively limited "Internet meme," which is often used as shorthand to describe funny pictures posted to the Internet. Internet memes in this more limited sense are of course memetic, but not merely because they're funny, or because they're pictures, or even because they're posted to the Internet. Rather, they are memetic because they are characterized by the following logics, which as Milner (2016) insists, subsume a vast range of communicative forms across era and media.

First, Milner argues, these media are marked by *collectiveness*: more than one person is involved in their creation, spread, and basic scrutability. An example from this volume includes the phrase "There will never be too many gravediggers for capitalism" (p. 35), a statement that, at the very least, prefigures an audience familiar with the form and function of anticapitalist critiques. Memetic media are further characterized by *spreadability*: they're shared between and across social collectives. Messages that include the term *enragés* ("the enraged"), which was adopted by student protestors to underscore their disgust with the French government, and in turn became more broadly associated with the student protest movement, provide an example. Additionally, memetic media are marked by *reappropriation*: they borrow from other sources. Exemplars include the slogan "Put a cop under your tank" (p. 9) a phrase riffing on an existing advertising slogan for a gasoline company ("Put a tiger in your tank"). These media also partake of *multimodality*: they comprise different communicative modes. In the case of graffiti, these modes include co-occurring textual, visual, and spatial elements. Finally, memetic media are typified by *resonance*: whatever is being shared is

interesting, infuriating, or simply instrumental enough to prompt that sharing—a point underscoring the impulse to produce graffiti in the first place.

Even the most idiosyncratic examples in this volume embody Milner's logics. The head-scratching statement "Live without dead time. Fuck without carrots" (p. 9), for example, still relies on collective lexicological norms; still spreads to the people viewing the graffiti, perhaps inspiring further gastro-sexual musings; still borrows from cultural and semiological referents; still depends on multiple media; and still resonates, since, clearly, the phrase was meaningful enough for the artist to communicate, for the photographer to record, and for me, in turn, to make a joke about. The same analysis can be applied to the volume's most explicitly political examples, and the whole spectrum of examples in between—just as it can be applied to the literally countless examples of public commentary, inside jokes, and of course funny pictures that make up vernacular expression online.

The fact that graffiti and online vernacular simultaneously enjoy so many points of overlap and so many points of divergence speaks more broadly to the benefit of comparing that which is (or appears to be) wholly

new with that which is (or appears to be) wholly superannuated. To fully understand emerging technology, media, and behavior, it's not enough to focus just on difference, or just on connection. Rather, one must be used as a counterweight for the other—points of connection employed to isolate the things that are truly different. Once these differences are isolated, it is then possible to evaluate why these differences matter ethically, aesthetically, and politically: the old, in this sense, helping to illuminate the new, and the new helping to illuminate the old, all the better to assess who, and what, truly have the floor.

References

Dundes, Alan. 1987. *Cracking Jokes: Studies of Sick Humor Cycles and Stereotypes*. Berkeley, CA: Ten Speed Press.

Milner, Ryan M. 2016. *The World Made Meme: Public Conversations and Participatory Media*. Cambridge, MA: MIT Press.

Phillips, Whitney, and Ryan M. Milner. 2017. *The Ambivalent Internet: Mischief, Oddity, and Antagonism Online*. Cambridge: Polity Press.

Afterword

glossary

Babeuf François-Noël Babeuf (1760–1797): French political agitator and journalist who claimed that "the French Revolution was nothing but a precursor of another revolution, one that will be bigger, more serious, and which will be the last." Accused of attempting to lead an insurrection against the government, he was arrested and guillotined.

Bastié Jean Bastié (1919–), urban geographer and professor at Nanterre in 1968, who strove to bring order back to the university after March 22.

Bonnot Jules Bonnot (1876–1912), anarchist, criminal, and member of the "Bonnot Gang," best remembered for inventing the "getaway car" in a robbery they undertook.

CA Comité d'action (Action Committee). Grassroots political organizations that sprang up everywhere, in all sectors of society, during May '68.

Censier "Censier is an enormous, ultra-modern, steel-and-concrete affair situated at the south-east corner of the Latin Quarter. Its occupants attracted less attention than did that of the Sorbonne. It was to prove, however, just as significant an event. For while the Sorbonne was the shop window of revolutionary Paris – with all that that implies in terms of garish display – Censier was its dynamo, the place where things really got done" (Solidarity, "Paris May 1968," in Dark Star, *Beneath the Paving Stones*, 81).

Claudel Paul Claudel (1868–1955), a right-wing Catholic poet particularly loathed by the surrealists for his "Catholicization" of Arthur Rimbaud.

CNJM Centre National des Jeunes Médecins (National Center for Young Doctors).

Cobblestone (also "paving stone") The most iconic weapon used by students and workers in the street against the riot police were the cobblestones pulled out of the pavement: a defense against the truncheons of the CRS, as well as a symbolic assault on the city planning of 1960s Paris.

Crozier Michel Crozier (1922–2013), French sociologist, and a professor of sociology at Nanterre who at that time became a focused target of derision for the enragés, particularly in regard to his admiration for the American bureaucratic system.

CRS Compagnies républicaines de sécurité: the national riot police.

Culture More often than not, a negative term in May '68, implicated as it was in the construction of "everyday life" that was being contested most broadly.

Cytherea The "lady of Cythera," also known as Aphrodite, the goddess of love.

Disorder Translation of *chienlit*, a forgotten expression (derived alternately from *chien-lit*, "dog-bed," or *chie-en-lit*, "shit in bed") until its infamous use by de Gaulle in his response to the events of May '68: "La réforme, oui; la chienlit, non" (Reform, yes; disorder, no).

Enragés The "enraged": a group of Nanterre students who adopted their name from the extreme revolutionaries (some would describe them as anarchists) who played a role in the 1793 Paris uprisings; influenced by the Situationist International, they were originally based at Nanterre where they contributed to the rise of the March 22 Movement and were responsible for some the best-known graffiti on that campus.

5th, the The fifth arrondissement of Paris, home to the Latin Quarter, the Paris universities, and where the events of May '68 first began to unfold.

Gavroche A character from Victor Hugo's *Les Misérables*, who has come to stand for the universal child of the streets.

German Jews Loaded words with a lot of history; a specific reference to the fact that the most public face for the student uprising, Daniel Cohn-Bendit (then known as "Danny the Red" and superficially characterized in the media as being the instigator of May '68) was born to German Jewish parents and labeled as such by his political opponents (who included the French Communist Party, along with such entities as *Minute*, a journal of the extreme right).

Godard Jean-Luc Godard, French New Wave filmmaker. He was not well regarded by the Situationist International, one of whose members was assuredly behind a bit of graffiti that didn't make it into Besançon's collection: "Godard: the biggest idiot of the pro-Chinese Swiss!"

Grouplets "Groupuscules," or little groups, designating the splinter leftist groups (mostly Trotskyist and Maoist in nature) both derided and celebrated by the right and the left over the course of May '68: a threat to more established parties and the instigators of the first stirrings in Nanterre in March that same year.

Huma *L'Humanité* (Humanity), the French Communist newspaper that (with the *Figaro*) quickly established itself against the student uprising by blaming the events on extremist groups and dismissing student leaders as "sons of the upper bourgeoisie."

JCR Jeunesse communiste révolutionnaire (Revolutionary Communist Youth). The organization, along with many others, would be outlawed in June 1968.

March 22 The day on which students and other political and cultural groups and individuals occupied an administration building at Nanterre University and held a meeting to address class discrimination and how the university was funded. In response, the administration called the police.

Môa An amalgamation of *Mao* and *Moi* (both of which in turn evoke the word lying phonetically in between them, the French word for May: *mai*).

Mob *La pègre*: an appellation used by Minister of the Interior (and former French Minister of National Education) Christian Fouchet against the protestors; among other such statements, Fouchet asked Paris to "vomit" the mob that was dishonoring it.

Nanterre The starting point for May '68 and home to the enragés and the March 22 movement. A concrete and glass Paris University located west of Paris in the midst of a wasteland and Arab and Portuguese shantytowns.

1936 The year of the Spanish Revolution; also the year a million workers went on strike in France (also from May to June), the Matignon Agreement was signed (establishing, among other things, the right to strike), and a left-wing government was formed.

Glossary

Odéon "On Wednesday evening, frustrated intellectuals and sympathizers will take over the Odéon Theatre, put up a black and red flag, and proclaim free entry to the students and workers. Many bourgeois will come to this place of instant discussion and public confessions. Theatre is the audience. An obvious popular success, very feeble stylistically, with occasional flashes of greatness" (Quattrocchi and Nairn, *The Beginning of the End*, 40).

ORTF Office de radiodiffusion television française: the French broadcasting service.

OSPAAL Organization for the Solidarity of the Peoples of Africa, Asia, and Latin America. Founded on January 1, 1966.

Para Short for "parachutist": "Where other elite regiments were dispersed within the army, the *parachutists* constituted an internal block or specialized sect, complete with their own uniforms, rituals, passwords, hermetic language, songs (frequently adopted from German S.S. songs) and *esprit de corps*: an army within the army" (Ross, *May '68 and Its Afterlives*, 37).

Pompidou Prime Minister Georges Pompidou (1911–1972) would be de Gaulle's successor in 1969 and France's most conservative president.

Rats "*Ratonnade*, a word used only up until that moment in reference to the hunting of Algerians ('*ratons*' or 'little rats' according to the racial slur) by the police or army, is taken up to refer to similar police operations against students" (Ross, *May '68 and Its Afterlives*, 34–35).

Reality On May 18, when Georges Séguy, General Secretary of the CGT (the largest of the French trade unions), was asked in an interview on Europe no. 1 as to what actions the CGT intended to undertake regarding the destruction of capitalism, he responded: "We must not take its desires for realities."

Sans-Culottes The Sans-Culottes – literally, the "without breeches" – were the working-class radicals (named for the fact that they wore trousers rather than the breeches of the upper classes) remembered for being the most active participants in the French Revolution.

Sciences Po Paris Institute of Political Studies (Institut d'études politiques de Paris). Renamed the Institut Lénine (and its hall and amphitheater named after Che Guevara and Rosa Luxemburg) during its seven-week student occupation.

Sorbonne Where May '68 proper began on May 3: police came to break up a student demonstration in the courtyard protesting the closure of Nanterre, promised the participants passage out of the Sorbonne, and proceeded to arrest them as they exited. After the removal of the CRS from the premises on May 13 and its reoccupation by the students, it would become a commune, open to all, until the eviction of the students on June 12.

Spectacle The best-known of the concepts contributed by Guy Debord and the Situationist International, the "spectacle" defines not something to be looked at but the relations between commodities, which in high capitalism have come to take the place of the relations between human beings.

Spontaneity A common reference point (albeit one that has been contested) in regard to May '68 is that it was a revolution in which action preceded theory: an essential spark to the events that quickly overtook the country, but also what some would claim to have been the ultimate undoing of the uprising. "For years, union leaders had done nothing but use the workers' struggle for their own bureaucratic advantage. 'There was nothing spontaneous about the events,' [Georges] Séguy [then General Secretary of the General Confederation of Labor] boasted in his 1968 report, and spontaneity is the chief enemy of all bureaucrats – it challenges their very existence" (Cohn-Bendit and Cohn-Bendit, *Obsolete Communism*, 154).

Street of the Schools Rue des Écoles: The main street leading to the Sorbonne.

Terrenoire Louis Terrenoire (1908–1992): former Minster of France and one of de Gaulle's close colleagues.

Touraine Alain Touraine, professor of sociology at Nanterre, who described the student uprising at the school as "a premeditated rape of the university" (*Harvard Crimson*, February 21, 1970). Touraine was, however, one of the professors to undertake a defense of the students who had been summoned to the Sorbonne disciplinary committee at the beginning of May.

Truncheon If the cobblestone had been the most iconic weapon employed by the students, the truncheon (*matraque* in French) was the most representative of the CRS: longer than the typical police club, made of wood, and coated with hardened rubber.

Undesirables Like "German Jews," a derogatory appellation applied to Daniel Cohn-Bendit (who was expelled from France as an "Undesirable") and subsequently embraced by protesters in solidarity.

Zamansky Marc Zamansky (1916–1996) was a mathematician and Dean of the Faculty of Sciences in Paris, who addressed the students and teachers on strike by television on May 15. Students viewed him and his efforts at instituting a selection process for admission to the Sorbonne as representative of de Gaulle's administration.

notes

1. *Con*: (fr.) stupid.

2. "Put a cop under your tank": Playing on the advertising slogan of Esso (later to transform into Exxon and then ExxonMobil) from the same time period: "Put a tiger in your tank."

3. "We want France French": One of the slogans used in the pro-Gaullist march on May 30, after de Gaulle's afternoon broadcast announcing his refusal to resign and that there would be a new election on June 23. Another slogan heard that same day was "Cohn-Bendit to Dachau!"

4. The echo of "beef" is an attempt in English to carry over some of the wordplay in the homonyms of "des veaux" (calves) and dévôts (believers). Despite his 1940 film *The Dictator*, the call-out to Chaplin would be better directed to Buster Keaton, whose movie *The General*, the title of which more directly evokes de Gaulle, is most likely the reference here.

5. "Long live the city united-to Cytherea": *unie-vers cithère*, a pun on *universitaire*. The cité universitaire is the university campus and, by implication, the dorms. One point of contention at Nanterre on the students' part had been the restrictions against students of the opposite sex visiting each other in the dorms.

6. The French is *Scrutin putain*: roughly, "fucking ballot." *Putain* means "whore" but is often used as a more generic curse. In either rhyme, the critique is either of de Gaulle's call for new parliamentary elections to take place in June 1968 or the vote on the resumption of work in the first week of June.

7. The homophonic wordplay of the original:
> *Des veaux*
> *dévots*
> *des votes.*

8. A reformulation of the classic Nazi-era phrase, "Whenever I hear the word 'culture' I reach for my revolver."

9. The first sentence paraphrases de Gaulle's description of his power grab in 1958.

10. *Trique*: a truncheon; a pun on "Tricolored."

11. The literal translation:
 Idiot
 Seals
 Buckets
 Ceaux
 Idiot
 So

12. The literal translation, which loses the rhyme:
 Civic
 snitch
 pig

13. While "pig" is common slang for policemen in English, *vache* ("cow") is the equivalent in French, which allows one to pass from police abuse to mindless consumption to a revolutionary dairy more easily.

14. "Let students study, workers work, teachers teach, and France be French – these were the terms of the call to order" (Ross, *May '68 and Its Afterlives*, 60).

bibliography

Atack, Margaret. *May 68 in French Fiction and Film: Rethinking Society, Rethinking Representation*. Oxford: Oxford University Press, 1999.

Cohn-Bendit, Daniel, and Gabriel Cohn-Bendit. *Obsolete Communism: The Left-Wing Alternative*. Trans. Arnold Pomerans. New York: McGraw-Hill, 1968; San Francisco: AK Press, 2001.

Dark Star, ed. *Beneath the Paving Stones: Situationists and the Beach, May 1968*. San Francisco: AK Press, 2001.

Feenberg, Andrew, and Jim Freedman. *When Poetry Ruled the Streets: The French May Events of 1968*. New York: State University of New York Press, 2001.

Gregoire, R., and F. Perlman. *Worker-Student Action Committees: France, May '68*. Detroit: Black & Red, 1969.

Quattrocchi, Angelo, and Tom Nairn. *The Beginning of the End*. London: Panther Books, 1968; London: Verso, 1998.

Rohan, Marc. *Paris '68: Graffiti, Poster, Newspapers and Poems of the Events of May 1968*. London: Impact Books, 1988.

Ross, Kristin. *May '68 and Its Afterlives*. Chicago: University of Chicago Press, 2002.

Viénet, René. *Enragés and Situationists in the Occupation Movement, France, May '68*. New York: Autonomedia, 1992.